I'm dangerous... I'm not gonna lie

erin smith

Sourcebooks

Published by Sourcebooks, Inc.
P.O. Box 4410, Naperville, Illinois 60567-4410
(630) 961-3900
Fax: (630) 961-2168
www.sourcebooks.com

Printed and bound in China.
LEO 10 9 8 7 6 5 4 3 2 1

......................................

I'm
dangerous...
I'm not
gonna
lie

......................................

SOMEONE ACTUALLY GETS US

This collection is dedicated to all of my newfound friends who have supported what I do in a fantastically unapologetic and enthusiastic manner. Also, to my girlfriends who know I am (for the most part!) emotionally unavailable... yet have not only embraced my honesty but also encourage it relentlessly.

Thanks for getting "on the bus."

Keep in mind I may be driving, but I don't always know where I'm going. And that's okay.

Xxoxxo, E

CONTENTS

inding humor in the mundane. Finding something—anything, every day, to put a smile on your face. Expressing yourself creatively, taking each day as it comes and surrounding yourself with like-minded people who get it. Who get *you*. That's what this book is about. Well, and not getting in trouble for all of the shit spouting out of your mouth. That's what I'm here for!

If there's one thing that I'm sure of in this life, it's that fact is stranger than fiction. Let's face it, this chunk of rock we live on is a hard place to maneuver sometimes. We get thrown curve balls every day…and all the meditation and vodka and yoga and screaming and kicking and not getting out of bed and wine and girls' nights out and crying in the whole world isn't going to boost your endorphins like laughing in the face of it all.

I like to say that I don't make it up, I just write it down (because you *know* it's what you're really thinking!). Knowing that you have someone to share the humor of life's trials and tribulations with? Someone that feels the same way you do? Well…we all know that *that,* my friend, is priceless.

If you don't laugh so hard at least once a week that you pee in your pants just a little, or let a few tears of happiness escape, or your face isn't sore the next day from smiling…you really need to try harder. I'm here for you. Just sayin'.

From here on out what you can expect to find is art that I have made from my heart with sayings that pretty much sum up my feelings on any given day. While I tend to be an introverted person for the most part (yes, seriously… that is not a joke. It's not…!), when I am required to engage, I make up for lost time and everyone around me knows it! These pages are separated into chapters that express the art of life and sharing it with the people that you've saved a seat on the bus for…and the ones you've shoved into the aisle.

Let's go.

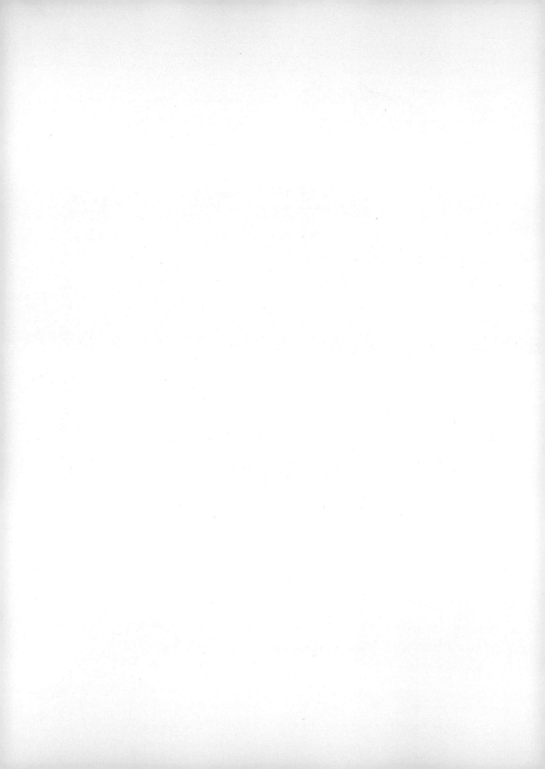

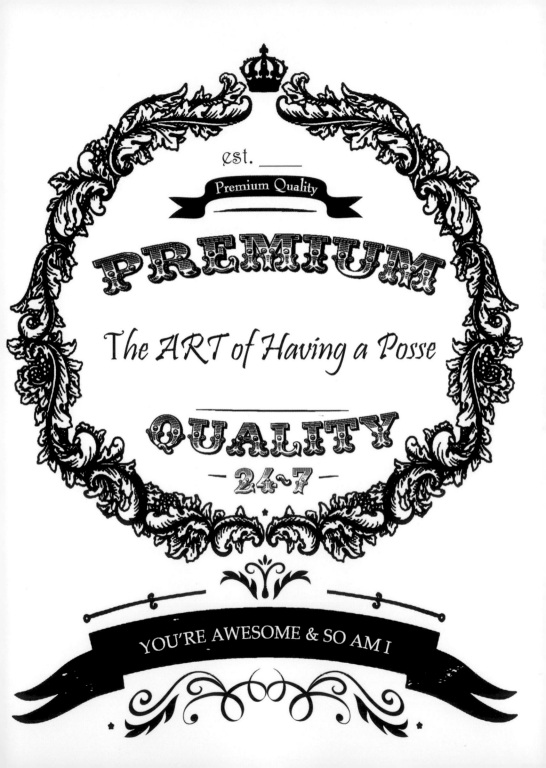

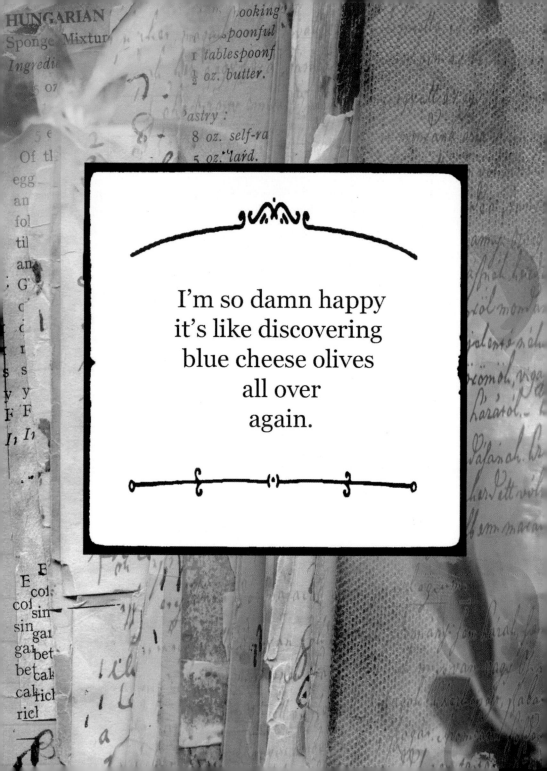

I'm so damn happy
it's like discovering
blue cheese olives
all over
again.

that one time?...when we did
that thing?...and we
knew we shouldn't
but we did anyway
because we
were laughing so hard?

that was
awesome.

Surround Yourself • with • PEOPLE YOU LIKE

"**A**re you going on the cruise?" A random statement from an artist that I've become friends with over the past few years. Apparently, a group of "creative types" (meaning women who wanted to get the hell out of dodge) had arranged an artist type retreat…on a boat…A BIG BOAT…to Belize. I paused for about half a second while the previous year, an endless, vacation-less one, passed before my memory, before enthusiastically replying "uh…duh, YES!"

Sounds great right?! Well, hell. I got sick. Literally, like day one. I'm positive it was my body finally saying "WHEW! You're taking a break? Me too… in a really expensive deck cabin on a really nice boat that you're never going to see because you won't be able to stand…or think."

Thanks to the assistance of one of my girlfriends speaking fluent Spanish and some excellent Mexican over-the-counter pharmaceuticals, I found myself one morning on an island, with my four friends bumping along on THE slowest rented golf cart on the planet…traveling seven miles on a rough sand road pocked with crater-like holes and being passed by military vehicles carrying militia and automatic weapons. My life mantra…I COULD NOT MAKE THIS SHIT UP. By the time we arrived to our destination (aka, a "private" club that turned out to be a thatched roof hut) I was done. DONE. I grabbed the leg of the closest chair I could find (which I'm fairly certain was a deck chair off a passing cruise ship that had most likely washed

up onshore) and dragged it through the sand to what meager shade was available. With complete and utter sincerity, I said to the girls…"all I want is a conch shell. A beautiful conch shell as a memento that I was actually here." Yes, it may have been the Mexican pharmaceuticals, but I was never more sincere about anything in my life.

In what seems like a short time later but turned out to be several hours, the girls shook me quietly (trying not to pop the blisters that had appeared…as I said, the shade was meager) and said it was time to go. I hated to get back on that golf cart. I looked around warily and next to my chair was the most beautiful pink and coral conch I had ever seen. Tears. TEARS of gratitude…I don't think I remember being so happy at my wedding…

That night as we were finishing up dinner, I turned and expressed my gratitude. I was truly moved that I had been given such a treasure.

My girlfriends smiled and looked infinitely happy. It was a special time… and then one of them said "Really? You kept the shell?? It was an ashtray we stole out of the bar!"

True friends just know what you need and will go through hell or high water to get it for you. And it'll be perfect.

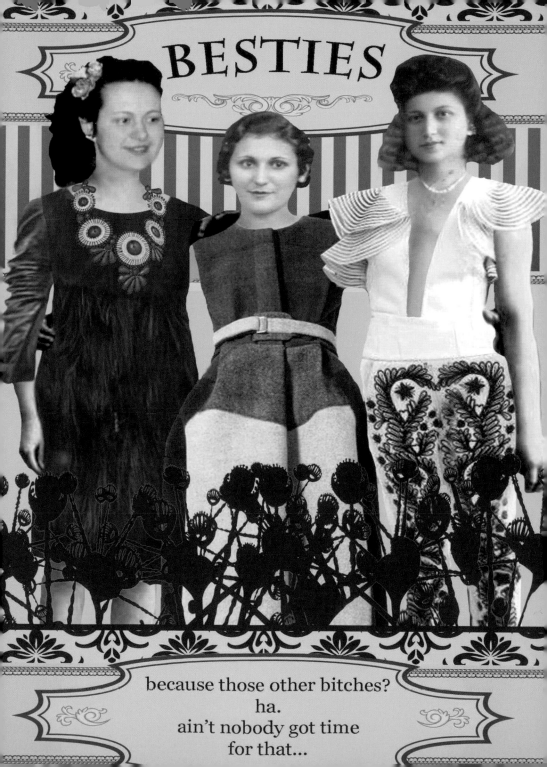

BESTIES

because those other bitches?
ha.
ain't nobody got time
for that...

I LOVE
WHEN YOU
LOOK
AT ME WITH
THAT
TWINKLE
IN YOUR EYE

we raise our
girls to
reach
for the sky...
but sometimes
it's still just
all about the dress.

today i will think
evil thoughts...
and try NOT to say
them out loud

the
super girl
cape is
in the
laundry.
you'll
just have
to take
my word
for it...

YOU ARE
SUCH
A DARLING...
don't make me lick you

i've been so
busy being fabulous
that i haven't
aged a bit

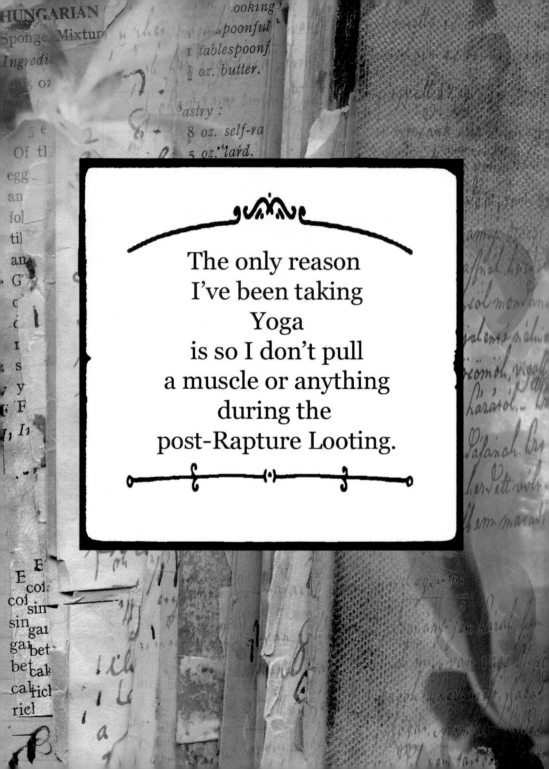

The only reason
I've been taking
Yoga
is so I don't pull
a muscle or anything
during the
post-Rapture Looting.

my workout
consists of
apocalypse screams
3 times a day

if you're always
looking down
for the perfect shell
you're going to miss
 all the other
perfectly
 fabulous crap
on the beach

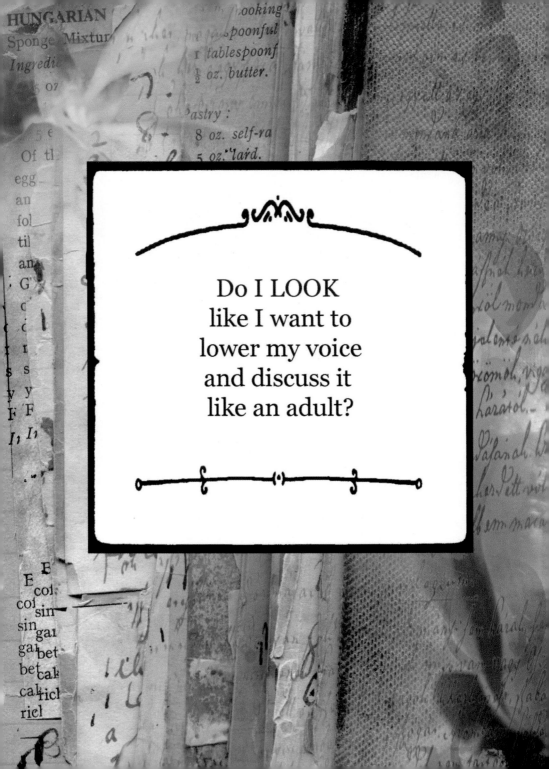

Do I LOOK
like I want to
lower my voice
and discuss it
like an adult?

sometimes...
i want
to scream

like

a little
damn girl

actually...it seems to be quite often

We'd Love to Come Over
• But Really •
Don't Go Through
ANY TROUBLE...

I really try and let things go once in a while. Not be so controlling…just "go with the flow." I also love to entertain. Sort of. I love to have my girls or my family or some neighbors over once in a while. I'd love to be organized enough to do it more often (or at least be home often enough to do it more often…) but I keep waiting for the "some day it'll all fall into place!" And that "go with the flow" thing? Ha. Yeah right.

While throwing together a spontaneous celebration for the evening, I stood in line for the checker at our local grocery (just a side note that I live in the city and we previously have had no mega-centers in town. Our new grocery/home store/book depot/eye center/office supply/pet superstore/hair/game/electronics/peanuts and burgers/mattress/shoes…AGH! It's a whole new world for us! I really think that if there was a cover charge at the three main parking lot entrance points and a few beer/wine carts scattered throughout, this could be a new model for shopping. I literally run into everyone I have ever met in my sixteen years here, and it's impossible to actually get anything done that you went there to do. That's the price we have to pay for having suburban stores in the hood—we're all flocking!) so… remember the checker?

This checker says to me, "what is this?" while referring to this gorgeous herbed goat cheese that I found over by the antipasto bar, and I said, well,

"cheese." She looked at me suspiciously, and said "this must be wrong, it says $8.99, let me get some help." As I tried to protest, she ran and got someone else, who verified, as I could have, that YES, it was $8.99. She looked at me again (and yes, the line is getting increasingly long behind me and I'm trying not to make eye contact with anyone), and said, "you're paying $8.99 for a little piece of cheese? Sheeessh." Yes, she actually looked at me and said "sheeessh" regarding my purchase. Unfortunately, at this point, I felt I needed to defend myself, and started making matters worse. "Well, it would cost three times that in a restaurant, and it will go perfectly…" She didn't buy it… and after each item she cast me a sideways glance…and when my items only filled two little plastic sacks and came to a total of $85, I swear she glanced at the people behind me in line, and then she whispered the total to me… obviously trying to save me from embarrassment. Sheeessh.

That evening on my deck as I was explaining my cheese saga, my girls nodded and smiled and glanced at each other. They munched on brioche with artichoke hearts and goat cheese and sipped Prosecco and giggled in all the right places and I thought, "They get me! They really, really get me." And it was good.

you
get
one shot.

make
everyone
wonder

how
the hell
you
do it

in flammen auf gehen

as much as
i try to be an
easygoing,
stretch your wings
and fly type...

i just can't stop
trying to burst people
into flames

with my mind

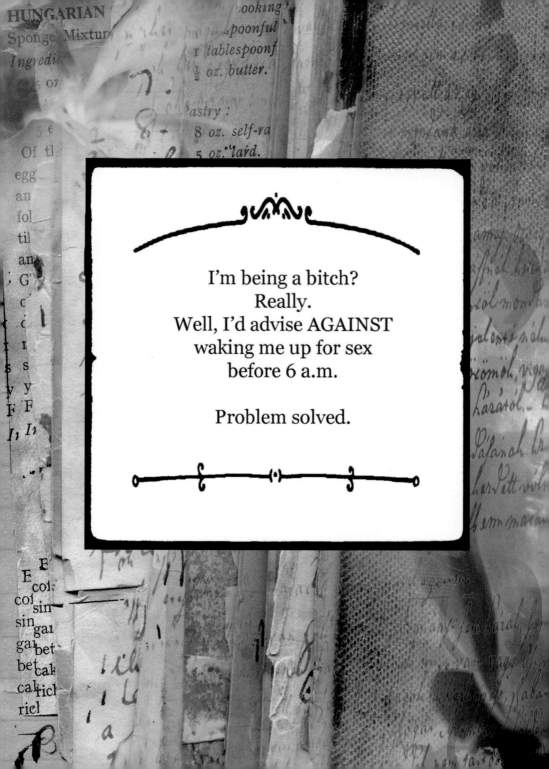

I'm being a bitch?
Really.
Well, I'd advise AGAINST
waking me up for sex
before 6 a.m.

Problem solved.

remember when
"sex, drugs, & rock 'n' roll"
meant something other than
"Sunday, anti-depressants,
& turn it down?"

I find it interesting that I can't remember what it was that I stayed up until 2 a.m. watching (unless I refer back to my Facebook status from last night)... and yet when I hear Cheap Trick on the radio I can remember the day I bought the 45 rpm record in 5th grade.

next time?
totally coming
back as a

rock star...

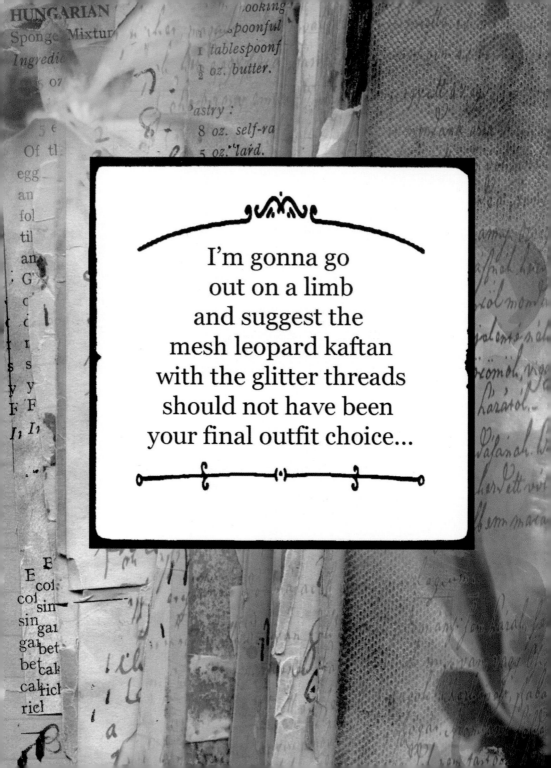

I'm gonna go
out on a limb
and suggest the
mesh leopard kaftan
with the glitter threads
should not have been
your final outfit choice...

when all else
fails...
just get
your
frock on

love me,
love my
big closet

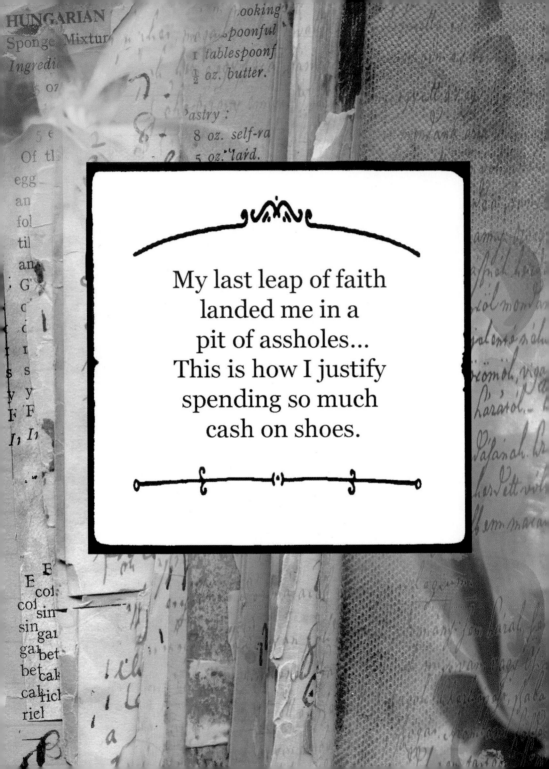

My last leap of faith
landed me in a
pit of assholes...
This is how I justify
spending so much
cash on shoes.

it's exhausting
being a
lover and not
a fighter...
especially when you
know one good smack
would end it.

I even impress
myself walking in
high heels,
but you should
see my friend Kevin...

she wanted to credit
her decision with
the wisdom of age...

but deep down she
knew it was
because of her
expensive underwear
& her
fabulous shoes.

We can't all
puke rainbows
and spit glitter...
but we can try
dammit.
We. Can. Try.

I try and work
the phrase "hard core"
into as many
conversations as I can.
It lets people know
you're serious.

you obviously have no idea who you're dealing with

GET REAL

They Don't Make 'Em
• Like •
THEY USED TO...

Recently a friend said to me, "No matter where we are in thirty years, promise me we'll show up at each other's mothers' funerals…just to verify for each other that she's really dead."

Being an adult can really suck. Before you know it, you're immersed in a life that you're not quite sure how it happened and after a time of winging it, you finally start to get in the groove. Ah…not so quickly grasshopper. Your parents. Friends' parents. The "adults" that you've known your whole life…cancers and strokes and heart attacks and surgeries and aging and unfortunately, death.

Yup. Meatballs start falling from the sky like scud missiles…phone call after phone call, email after email. When it rains it pours…or are we…dare I say it…just "that" age?

My girlfriend's grandmother, whom we'd always admired as living life "right" and having the proper attitude and philosophy on living (i.e., always said what she thought, had impeccable taste, and usually had a cocktail nearby) was "protected" by her family recently by NOT being informed of her own daughter's breast cancer.

My girlfriend's grandmother, shortly before her own recent passing, spoke candidly (one of the reasons we love her, remember?). With a highball in her hand, and the ever present tinkle of her ninety-three years of charm, said "Darling, I'm worried about your mother." With a sinking feeling that she

had found out about her daughter's cancer, how surprised was her grand-daughter to hear her continue, "Darling, your mother doesn't smoke. She only eats vegetables and fruits. She doesn't date. She doesn't drink...she doesn't even eat candy! Honey, I'm just afraid that she's gonna die of boredom."

Oh, to have such perspective!

Regardless of age, as long as there are mothers, there will be adult children to torment (torment, it seems, to be a popular perspective from their now adult children). So. Highball in hand, and life taken with a grain of salt, I toast grandmothers and granddaughters, and the mothers that brought them together.

I'd love to
help you out...
but,
*Celtic Women:
Endless Journeys*
is on PBS.

and you always
hear how
size doesn't matter...

your boots
may be
made for walking...

but mine are
in case
i need to kick
your ass

I'm a yoyo dieter.
I only schedule
family pictures on
the years when
I've lost weight...

i've had it
up to here
with all of this
inspirational
bullshit

i'm sorry,
i just
please need you to
shut up
for one minute...

Please excuse the
interruption
but I am officially
declaring today as
"Mimosas and Kites day."
As you were.
Thank you.

there comes
a time when you
have to take
it seriously. a
no smoking,
regular exercise,
gluten free,
multivitamin,
yoga,
no carbs,
low sugar,
probiotics,
meditation,
boot camp,
no alcohol,
flax seed,
vegan,
locally grown,
lifestyle.

Good luck not dying
of fucking boredom...

i may appear
harmless...
but inside
i'm completely
badass

The shit you can do
blows my mind.

·U R PREMIUM QUALITY·

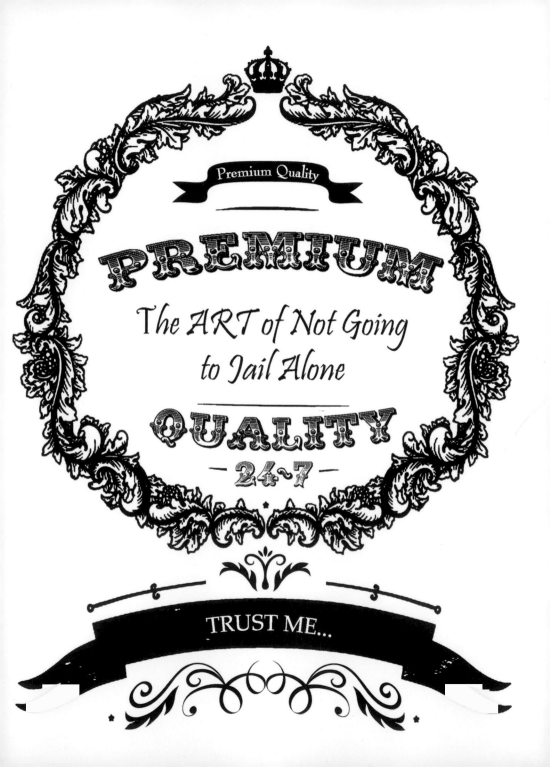

I'd pray for me,
but even
I don't think
I'm that much
of a hypocrite.

i love me
some jesus
but i
WILL
slap you
bitch

Use it and be blessed.

I Can See Russia
• From •
MY HOUSE...

It's easy to be anonymous these days. You can give your opinion regarding anything under the sun from the comfort of your own bed. Trying to maintain your "happy face" in public when all you want to do is go home and pull up the covers? Well, damn. For the record, there are a plethora of things I do better!

When I was younger, people would always say I reminded them of Debra Winger. Most recently this has turned to Tina Fey. I love Tina Fey, don't get me wrong…but I think it's the hair color and the glasses more than anything.

Recently I was back in town after a whirlwind show season of about seven weeks in different cities and all I really, REALLY wanted was to be at home ignoring my unpacked suitcase and dirty clothes, snug in bed with a book and a huge glass of wine. With the bottle on the side.

But sometimes you just gotta do some shit you don't want to do. A concert. Ohhhhhkay. I was standing with some friends when a few women I recognized but didn't know very well approached. They were being very sweet and talking about my work and how they can relate and…long story short I felt my eyes glaze over and I went brain dead. My friends looked slightly panicked and as I was shaking my head to tell them not to worry about it… an apparition appeared. The crowd parted like a sea as a gentleman with long, kinky gray hair and a beard to his chest…not so much wearing as owning a full-body, tie-dyed jumpsuit lurched toward us. We were all fairly

slack-jawed in awe, and as I wondered to myself if I was witnessing the ghost of Wavy Gravy or Jerry Garcia himself, he leaned in to me, his big arm reaching out to grab my hand. He was shoving a huge joint…like Cheech and Chong marijuana cigar…into my hand. Time stopped momentarily as I took in the faces of the women around me and their inquiring expressions… Without missing a beat the man screeched "HEY! I WANNA GET HIGH WITH SARAH PALIN!!" My girls almost fell on the floor from laughing… but it was the diversion we needed to make a clean break. Omg. Thank you so very much, Tina Fey.

I had a headache
for like 7 days
and I was going completely
insane and I thought,
"WHAT HAVE I DONE
TO DESERVE THIS?"
Oh. Well yeah...
there was THAT...

if 50 is the new 40...and
40 is the new 30...
then all that crap i put you thru
awhile ago is
nothing
compared to the
shitstorm ahead

You seriously
do not want to
mess with me today...
I was out of
Weight Watchers
points by breakfast.

i can totally
control
myself...
i just totally
choose
not to

Sometimes
the only thing
I feel in control of
is my alcohol intake...
and that's
only fleeting.

it's
a little
thing called
RESTRAINT
you should
try
it sometime

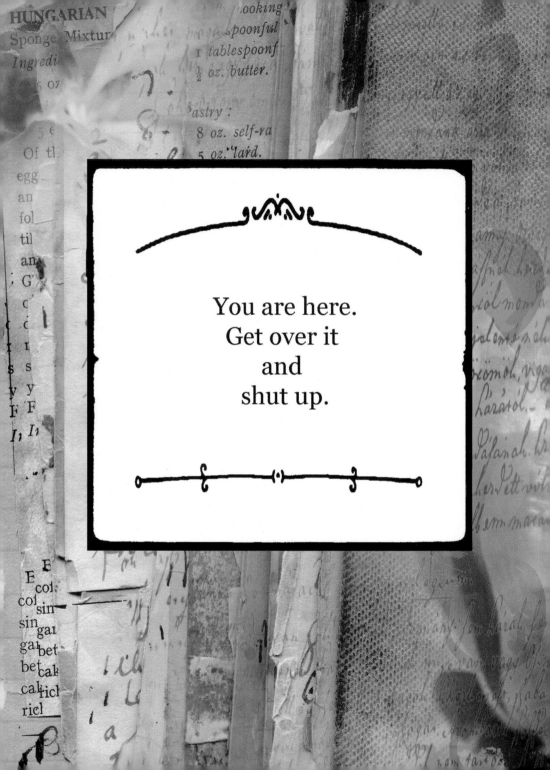

You are here.
Get over it
and
shut up.

sometimes your friends
pick you...

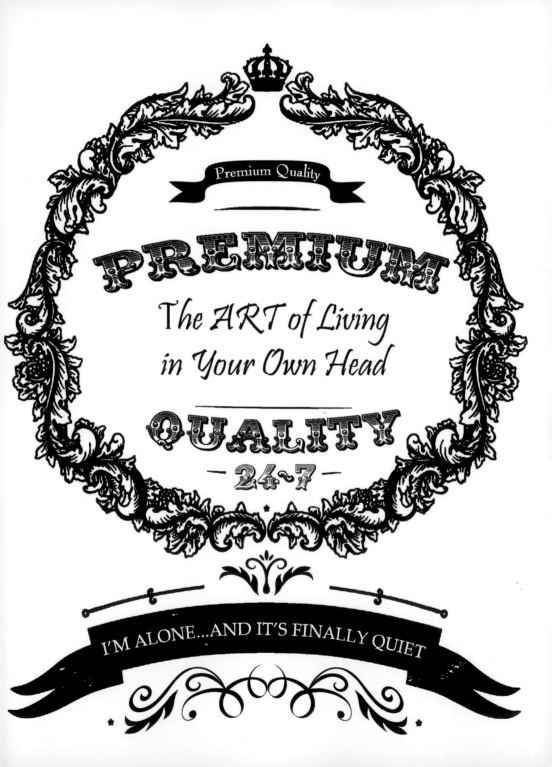

My favorite guy
at the airport
is always
the guy in the
sombrero.
I love him.

life is
a three ring circus...
eat the cotton candy
and just ignore
the scary clowns

. My Spirit .
ANIMAL

While I'm not the meditative sort, I am always in my own head. Usually thinking "really?" or "what the hell?" or "I took half an Ambien, why am I still awake?" I'm often incredulous at the situations I find myself in. I think "…have I been set up? Am I on *Punked*?" Then clear as day, I think…NO. I could not make this shit up.

As a transplanted Midwesterner, I take advantage of the mild weather we have in the South and frequently have doors and windows open. In my studio one morning, a shadow (very similar to those freaky ghost bad guys in Harry Potter) passed over my head. I hit the ground hard, pulling off an impromptu yoga move that most Swamis in India would have been jealous of. There was a wren…being chased by a damn HAWK. In my office. The wren, after several giant circular flying-for-its-life laps, slammed into the wall. The hawk circled once more and left through the door it had entered.

My arms flayed wide, my chest lying prone on the ground, the bird lying a couple of feet away, both of our chests heaving. Me, incredulous not only about the appearance of a hawk but also that I had not had a heart attack (I was fairly impressed actually…at the not having a heart attack part). The bird and I made eye contact and I'm quite certain if he had spoken out loud, a warbled "oh my God, what the fuck?!" I would have taken it in stride.

Eventually, he recovered and left…and I, being more introspective than usual (because I hadn't had the heart attack) thought "this has to be some kind of sign." The hawk would have been too obvious…the wren and I had

shared a "moment." The interwebs informed me that the totem of the wren gives me the ability to adapt and be resourceful. To use what is available. That wrens are fearless and bold and are overflowing with confidence. At this point I thought that well, perhaps I'm too much of a realist after all…to be reading this much into almost being killed by a bird. Then I read the final descriptor of that wren's totem: That they often get so wrapped up in work that they sometimes forget to sing, but when they do they are capable of being extremely noisy and sound much louder than their actual size.

Nailed it!

You know you've
grown up when
"beer goggles" actually
means wine...
and refers to your
yearly jaunt on
the neighborhood
Tour of Homes.

if you're
alone in
the forest
and you spill your
last glass of
wine...
can you
suck it out
of your shirt?

No. 24

I'm not an evil person.
In fact, I'm not
even mean...
I just have a
really low tolerance
for idiots.

idiot, *n.* mentally defective. imbecile, moron (STUPIDITY); fool, tomfool, witling (FOLLY).

most of
the people
around me...
on any
given day

Lately, so many things
require such
a leap of faith
i don't even bother
to take my
shoes off...

it's easier to stay
somewhat grounded if i
can let my mind roam
around on its
own most of
the
time

You may not think
I did much today,
but I think pretending
that I knew
who you were at
the grocery store was
quite the
accomplishment.

my face hurts.
from pretending to like you...

your
obsession
with gardening
has really
gotten
annoying...

If my children
have any friends left
by high school
(when I've managed
to alienate all
of their parents)
it'll be a true miracle.

it's nothing
personal.
i treat everyone
with
equal
disdain

i am being nice...
just in a
very awkward
way

I don't know WHAT it does... but isn't it fantastic?

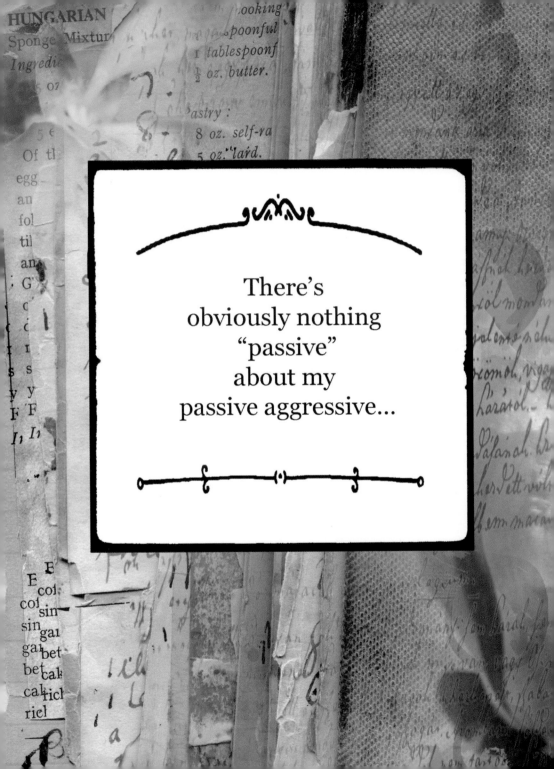

There's
obviously nothing
"passive"
about my
passive aggressive...

i promise
to do my
job to the
best
of my
ability...

when & if
i feel like it

Ms. Passive Aggressive

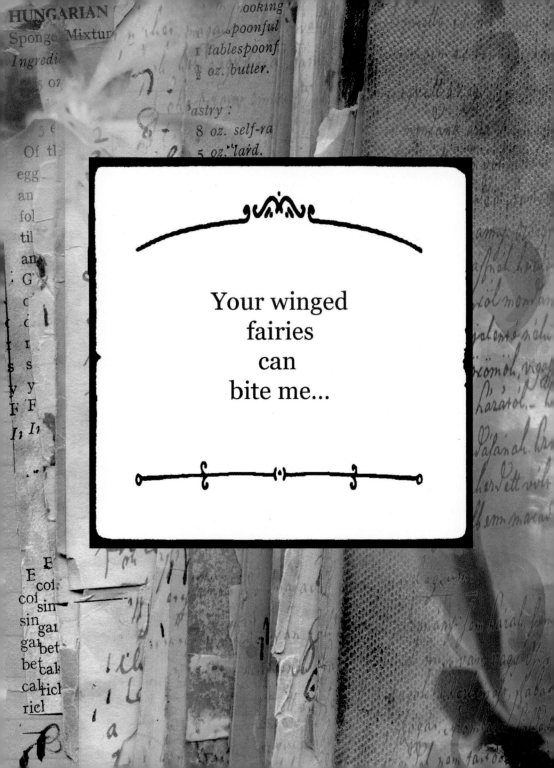

Your winged
fairies
can
bite me...

what fresh hell is this?
~Dorothy Parker

son of a bitch... i wonder what else my mother was right about?

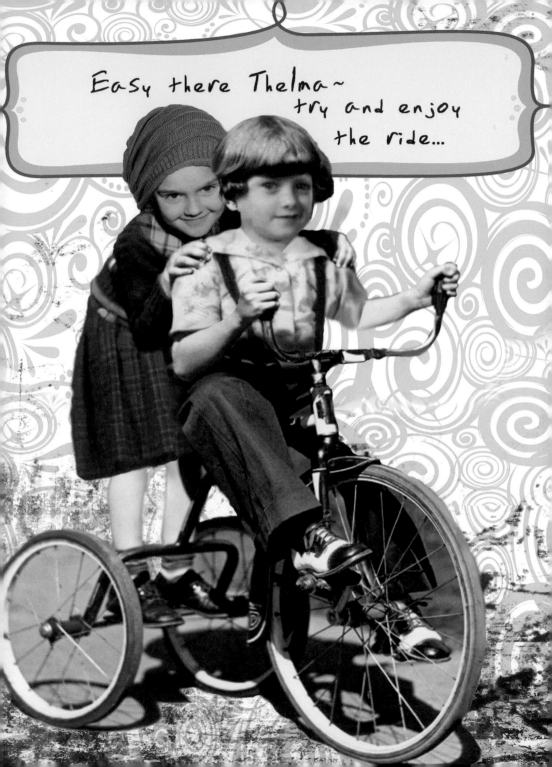

There was a time long long ago when an iota of shyness may have been evident as the photo indic OH! but that was so long

live
like you
don't give
a shit
WHAT
PEOPLE
say...

I LAUGH IN THE FACE OF IMPOSSIBLE

he said i was an
irrational bitch...
and i was all
like, um,
hello...
have you ever
met me?

do you mind
holding
 my calls
during
 my slow
descent
 into
 hell?

· I'm ·
ELECTRIFYIN'

I love my family. I love my friends. I really, really, really love to be alone. I don't think that is unusual…I'm either socially all in or I'm out. I've moved a significant number of times, which puts me in the social situation to fall into various and sundry new groups of girls. It has been about thirty years since my first big cross-country move and it has become apparent to me that there seems to be a pattern…

After a move into a new office a while ago, I kept getting shocked. Not shocked like I've been dragging my feet across the carpet and touched you shocked…I mean like I went to move a metal fan and a bolt of electricity and a scene from the movie *Powder* ripped through my body…like I touched my computer tower and thought maybe I caused a blackout to half of the city.

Being the responsible person that I am (ha! just kidding, I just don't want to die) I called the electrician. He came and listened to my description of the problem. About thirty minutes later he was gathering his stuff together with an "Okay, I'm done here."

I hadn't moved, and yet hadn't seen him really do anything. "Sooo…did you find the problem?" He replied matter of factly that there was no problem and explained that some people are just "highly charged."

Highly Charged. What. The. Hell? I've been called a lot of things in my life…however, "highly charged" has never been one of them. I suppose there's a first time for everything. I was kind of shocked (ha…shocked? get it? Yes, I'm a dork), you know…for like ten minutes, then my entire life pretty much made complete sense.

As much as I may unintentionally try to push people away sometimes, it just never really seems to be successful…and the end result is that I always end up with a great group of people around me that are available at the drop of a hat. I've just always assumed I was just lucky that way.

I'm officially a freak magnet.

Boot Camp.
Helping women get
more shit done by 9 a.m.
than they used to get
done all day.

if i wasn't so
tired
i'd come over there
and
totally
slap the crap
out of
you

I was
totally motivated
to start my
diet today
until I found the 1″ hair
growing out of
my eyebrow.

i try to live
simply,
but DRAMA
just keeps
following
me around...

Eat. Pray. Bite me.

I haven't
even
had my
coffee
yet...
namaste
this.

i'm having one
of those days
where i just want
to say "fuck you!"
grab a couple of
beers,
and deploy
the
emergency
slide...

it's never too late
to be whatever
you wish
to be.

as long as it
doesn't negatively
affect me
in any way.

while i admire the
glass is half full type...
i'm comfortable
with the fact my glass
will always
have a slow
and
steady leak

Just when
I think
people can't
piss me off more,
they totally
surprise me.

i'm dangerous...

i'm not
gonna lie

I don't think
you can
Facebook
a condolence.
Really.

don't make me
take you
off my
"friends"
list...

because
i will.

So...when you see
me today and think,
"Huh...whatever...I don't know
who she thinks she is
being all fancy..."
rest assured the feathers
are from my down pillow
and I just said screw it...

oh yes...
i'm really
into
juicing
right now
too...

judging
from your
expression
i'm going
to guess
i said that
out loud...

I'm
fine!

more than
a little
crazy...
but fine!

all i know
is the recipe
called for a
cup of sherry...

holy
shit...
we have
it all.

Sometimes It's Hard
• to Get Me to •
SHUT UP

umor, for me, has always been a defense mechanism. I figure…if someone is laughing, their heart has to be getting some of that extra oxygen, yes?

I think that it's amazing that people take the time out of their lives to make contact with me. Letting me know where they've seen my art, or sharing how running across my cards in an airport shortened their endless flight delay, or, more recently, how in times of dire circumstances and extreme distress, that my cards were the only thing that was deemed appropriate.

Really? My cards? I categorize people into two groups. "On the bus" or "off the bus." The people who get the humor are definitely "on the bus" as far as my referencing is concerned. The people who are off the bus are the ones who question me and ask, "Who in the world would you give this to?"

I know that I personally do not deal well with uncomfortable situations. What do you say when there simply ARE NO WORDS? I tend to wait and wait as I try to grasp the situation and usually end up stressed that I have taken too long and now what do I do?

A message I've been receiving over and over lately is from people who have something huge that is impacting their lives. Not only have they not been laughing, the friend or sister or parent that is struggling has basically forgotten how.

I woke recently to the usual myriad of email. One in particular stood out.

"…got your cards today. Have tried to share them as much as possible with all I know. I am especially excited to hand deliver one to my sister. She's been having a hard time the last year or so and I know that this will certainly bring a much needed smile to her face. AWESOME!!"

Laughter IS healing.

I fucking love you people.

· *Author* ·
BIO

Erin Smith has loved making art since her first art class at the age of twelve. A sale at the age of fifteen was all of the encouragement she needed to spend as many hours a day in the art studio as she could get away with.

Writing came naturally, and a creative writing scholarship ultimately propelled her into the Environmental Design School at the University of Colorado, where she graduated with a BS in Environmental Design. After spending several years having her creativity crushed working in architecture, she eventually shifted her career path to hospitality, where waiting tables guaranteed her a place back among the living. There she proceeded to gather stories and became increasingly, albeit comically, bitter and jaded.

After traveling thru Europe and living in several time zones, Erin made Atlanta, Georgia, home. While expecting her first child and trying unsuccessfully to decorate a nursery with anything store bought that didn't suck, she was compelled to start painting again, incorporating children's themes with prose. Staying at home, raising her son during the day, and waiting tables in the evening ultimately led to her iconic, alcohol-related, and snarky artwork featuring her personal family photos and original sentiments.

Erin Smith Art was founded in 2005 and the hospitality apron was literally burned. (Do not try this at home, whatever those aprons are made of "melts" rather than burns). Much to her delight, people around the globe have embraced her humorous, tongue-in-cheek sentiments as their own, and

her artwork has become a staple in boutiques and box stores alike. Currently, Erin Smith Art and her Holy Crap brand can be purchased in nine countries. Erin is frequently asked to speak publicly about her story and has been featured in various publications. She is one of *Stationery Trends* top 10 Designers to Watch in 2014.

While she has kept a blog since before blogging was cool, this is her first book that pairs her essays with her artwork.

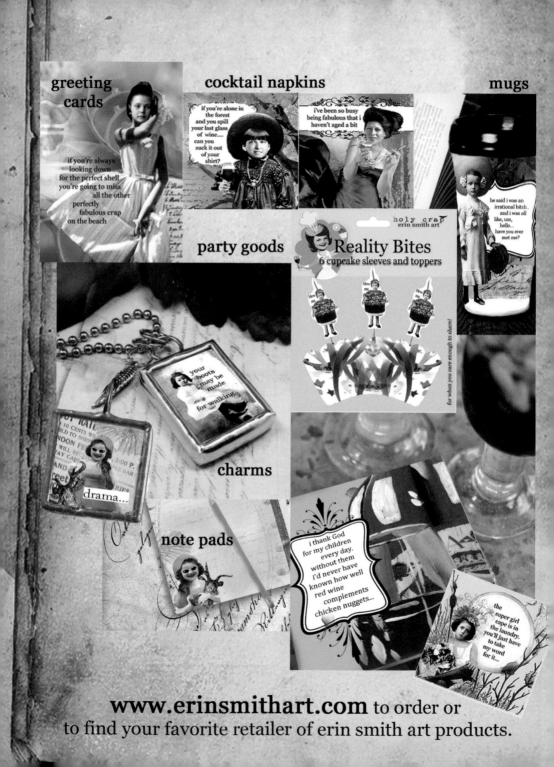

greeting cards

if you're always looking down for the perfect shell you're going to miss all the other perfectly fabulous crap on the beach

cocktail napkins

if you're alone in the forest and you spill your last glass of wine.... can you suck it out of your shirt?

i've been so busy being fabulous that i haven't aged a bit

mugs

he said i was an irrational bitch... and i was all like, um, hello... have you ever met me?

party goods

holy crap
erin smith art

Reality Bites
6 cupcake sleeves and toppers

for when you care enough to share!

your boots may be made for walking...

drama...

charms

note pads

i thank God for my children every day. without them i'd never have known how well red wine complements chicken nuggets...

the super girl cape is in the laundry. you'll just have to take my word for it...

www.erinsmithart.com to order or
to find your favorite retailer of erin smith art products.

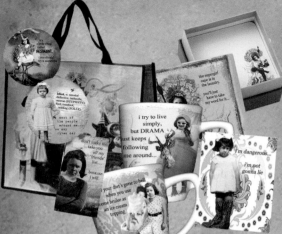

www.enescousa.com

various gift
items: mugs, journals,
totes, bookmarks,
stone coasters, totes
and more.

wall plaques,
neoprene costers,
textile items.

www.highcotton.com

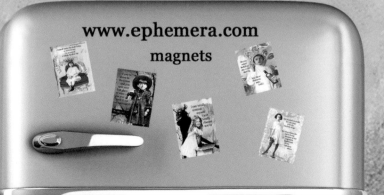

www.ephemera.com

magnets

A new year?
Bring. It. On.

Dive into
the new year
armed with
some sassy snark!

Introducing the 2015 Erin Smith Wall Calendar and 2015 Erin Smith Planner! Perfect for keeping track of all your mischief.

CALENDAR INCLUDES ORIGINAL ART AND LAUGH-OUT-LOUD QUOTES LIKE:

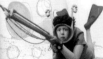

2015 ERIN SMITH PLANNER
9781492604099
$14.99

2015 ERIN SMITH WALL CALENDAR
9781402298967
$13.99

"I can totally control myself. I just totally choose not to..."

"I laugh in the face of impossible!"

"Son of a bitch... I wonder what else my mother was right about."